The Art of Drawing
FAVORITE PETS

Pencil is an ideal medium for any beginning artist. This forgiving tool has a small tip and allows an easy grip, affording artists great precision and control over their strokes. And because drawing is the basis for all the visual arts, it is the perfect starting point for any artist who wants to branch out to other media, such as oil pastel or paint. But pencil is also a beautiful art form of its own, with the potential for producing endless values and intricate textures. In this book, you'll learn about the basic supplies used in pencil drawing, as well as techniques specific to rendering animal skin and hair. You'll also find 17 engaging animal portraits to follow and copy—from a fluffy hamster to a sleek Doberman. And once you've completed the projects, you'll have all the information you need to draw your own pet portraits. —*Mia Tavonatti*

CONTENTS

Choosing Tools

Pencil drawing offers an approachable and practical introduction to art for any aspiring artist. Only a few materials are needed to begin, which can be easily transported just about anywhere. Drawing tools are also relatively inexpensive, so the initial investment isn't overwhelming. When you're just starting out, however, it's best to purchase the highest quality materials you can afford at the time. Better-quality materials are easier to use and produce more satisfying results; they will ensure that your pet drawings will last longer and won't fade or yellow over time. Here you'll find a helpful overview of the tools you'll need to begin your own drawing adventures!

▶ **SKETCH PADS**
Sketch pads offer drawing paper conveniently bound into book form. They are useful for making quick sketches and when drawing outdoors. They also are available in a wide variety of sizes, textures, and bindings. You may want to begin with one that has a smooth- to medium-grain paper texture, which provides the most versatile drawing surface.

▲ **YOUR WORK STATION** You don't need to have a full studio setup to start drawing, but a well-lit, comfortable area will provide the most efficient work environment. Make sure you have plenty of natural lighting; and if you draw at night, use both soft white and cool fluorescent bulbs so that you have both warm and cool sources of light. You'll also need a hard, sturdy work surface and plenty of room to lay out all your tools. In addition, a padded chair will help make long drawing sessions more comfortable.

▶ **DRAWING PAPER**
Most artists use single sheets of higher quality drawing paper for finished artwork. Paper is available in a range of surface textures: smooth grain, medium grain, and rough to very rough (which "catches" the most graphite for heavier strokes). Vellum-finished paper, which is translucent in appearance, has a very smooth and slick surface that allows for silky pencil strokes. Tracing paper is another option, and it's an inexpensive alternative to vellum.

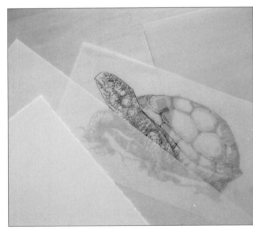

◀ **ERASERS** A kneaded eraser is an essential tool. It can be formed into small shapes to remove pencil from very tiny areas or to gently blend strokes. Vinyl erasers are best for larger areas, and they remove pencil marks completely. As long as you don't scrub too vigorously, neither type will damage the surface of your paper.

▶ **BLENDING STUMPS**
Tortillons are rolled paper "stumps" used to blend and soften pencil strokes. They're handy for small areas where your finger or a cloth is too large. You can also use the sides to quickly blend large areas. When the stumps become dirty, simply rub them on a cloth to remove the excess graphite.

▶ **STENCILS** Although I do most of my initial blocking in with freehand shapes and lines, some drawings call for more precision. I keep on hand a supply of stencils with a variety of circles and ovals, curves, and straight edges that I use for tighter drawings.

▲ **SHARPENING TOOLS** Utility knives— or craft knives—come in a variety of shapes and sizes and are great tools for sharpening pencils. I use them interchangeably with a handheld pencil sharpener and a sandpaper block to alter my points. (See page 3.) The knife and sandpaper produce the widest variety of points.

SELECTING YOUR PENCILS

Pencils are labeled with numbers and letters, and the combination indicates the softness of the "lead" (actually graphite). Pencils labeled B are soft and produce heavy, dark strokes; those labeled H have hard lead that creates thin, light lines. HB pencils are in between hard and soft, making them a good, versatile beginner's tool. The higher the number that accompanies the letter, the more intense the softness or hardness of the lead. (For example, a 4B pencil is softer than a 2B, and a 4H pencil is harder than a 2H.) The projects in this book call for H, HB, 2B, and 4B pencils, but you may want to experiment with others as well.

GATHERING OTHER DRAWING TOOLS

I start my drawings with graphite pencils, but I also like to use other tools as my pieces progress. For example, Conté crayons or charcoal produce chalky, smudged lines that soften the look of a subject. Outlining a drawing with black ink really makes a subject "pop." (See page 30.) And thin washes of ink (or black watercolor) applied with a paintbrush produce smooth shadings. (See page 31.)

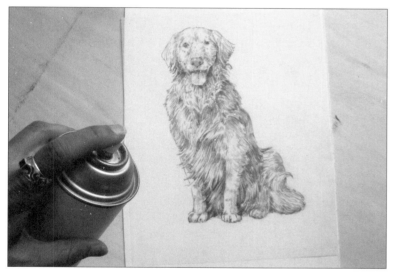

SPRAY FIX A fixative "sets" a drawing and protects it from smearing. Some artists don't use fixative on pencil drawings because it tends to deepen the light shadings and eliminate some delicate values, but it is very good for charcoal drawings. Fixative is available both in spray cans or in bottles; the latter requires a mouth atomizer. Spray cans are more convenient, and they give a finer spray and more even coverage.

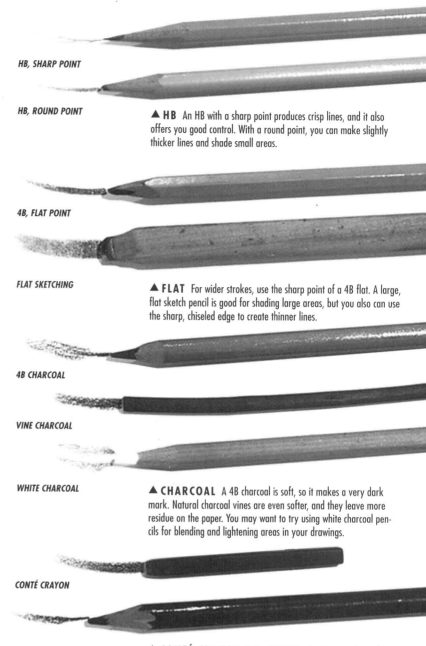

HB, SHARP POINT

HB, ROUND POINT

▲ **HB** An HB with a sharp point produces crisp lines, and it also offers you good control. With a round point, you can make slightly thicker lines and shade small areas.

4B, FLAT POINT

FLAT SKETCHING

▲ **FLAT** For wider strokes, use the sharp point of a 4B flat. A large, flat sketch pencil is good for shading large areas, but you also can use the sharp, chiseled edge to create thinner lines.

4B CHARCOAL

VINE CHARCOAL

WHITE CHARCOAL

▲ **CHARCOAL** A 4B charcoal is soft, so it makes a very dark mark. Natural charcoal vines are even softer, and they leave more residue on the paper. You may want to try using white charcoal pencils for blending and lightening areas in your drawings.

CONTÉ CRAYON

CONTÉ PENCIL

▲ **CONTÉ CRAYON OR PENCIL** Conté crayon is made from very fine Kaolin clay. Originally it came only in black, white, red, and sanguine sticks, but now it's also available in a wide range of colors. It's also water-soluble, so you can blend it with a wet brush or cloth.

Varying Points for Versatile Strokes

SHARP POINT Use a handheld or an electric sharpener for a simple, sharp tip. The fine point can be used to create extremely thin lines and small details. You also can use the side of this tip to produce thick strokes—perfect for quickly shading large areas of fur or backgrounds.

FLAT POINT For this tip, use a utility knife or sandpaper to flatten the lead of a soft pencil, creating a blunt, squared end. This shape can produce a variety of different strokes simply by changing the angle of the pencil to the paper; use the edge for the thin lines of your animal, and use the flat tip for wide lines.

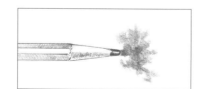

ROUND POINT To round the point, sharpen the pencil first; then hone the tip on a fine-grain sandpaper block. The rounded shape produces medium-thick lines that are softer than those created by a sharp point but that still have some texture, ideal for animal fur.

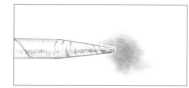

BLENDING To blend your individual strokes into a single mass, use the side of the rounded tip of a tortillon. (I sometimes use a kneaded eraser or cotton swab for this task as well.) The blended strokes can represent smooth skin or very soft fur.

Getting Started

Before you begin sketching, you'll want to get accustomed to using your whole arm—not just your wrist and hand—to draw. (If you use only your wrist and hand, your sketches may appear stiff or forced.) Practice drawing freely by moving your shoulder and arm to make loose, random strokes on a piece of scrap paper. Try to relax and hold your pencil lightly. You don't need to focus on a particular subject as you warm up—just get used to the feel of a pencil in your hand and the kinds of strokes you can achieve.

LEARNING CONTROL

Once your arm is warmed up, try the strokes and techniques shown here. Although making circles, dots, scribbles, and lines may seem like senseless doodling, creating these marks is actually a great way to learn control and precision—two traits essential to pencil drawing. You should also experiment with different pencil grips to see how they affect the lines you draw. The more you practice with different strokes, sketching styles, and grips, the quicker and more skilled your hand will become!

▶ **PRACTICING LOOSE STROKES** Although drawing requires a certain amount of precision, loose strokes are also essential to the art. Free, circular strokes are great for warming up or for quickly recording subjects, such as the rough shape of a pot-bellied pig.

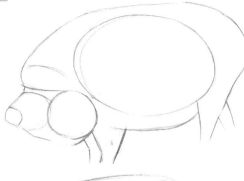

▶ **VARYING EDGES** Making small adjustments in your drawings to suit your subject is important. For example, pencil strokes that follow along a straight edge are ideal for creating striped fur. But free edges are more appropriate for creating a natural-looking coat, as straight edges can make the hair seem too stiff. Edges created with an eraser also have their place — these lines can be used to provide a smooth transition between textures or values.

Erased edge

Free edge

Straight edge

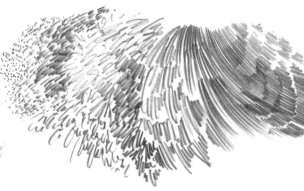

▲ **MODIFYING STROKES** You can capture the length, thickness, and texture of an animal's hair by varying the length and curve of your strokes. Small dots are perfect for short, bristly fur; scribbles are appropriate when hair is thick and frizzy; and long, sweeping strokes imply smoothness. Try varying the pressure of your pencil and the length and curve of your strokes to see what you can do!

Gripping the Pencil

HANDWRITING The handwriting position provides the most control, and the accurate, precise lines that result are perfect for fine fur details and accents. When you use this position, place a clean sheet of paper under your drawing hand to prevent your palm from smudging your drawing. And sharpen your pencils often to keep your strokes delicate.

BASIC UNDERHAND The basic underhand position allows your arm and wrist to move freely, making it ideal for fresh and lively sketches. Practice this position when sketching animals from life. Drawing in this position makes it easy to use both the point and the side of the lead by simply changing your hand and arm angle.

UNDERHAND VARIATION Holding the pencil at its end lets you make very light strokes, both long and short. It also gives you delicate control over lights, darks, and textures. The soft lines are ideal for quick sketches on site and for smaller areas of shading or texture.

BASIC TECHNIQUES

Practicing basic techniques will help you understand how to manipulate the pencil to achieve a variety of effects. Pencil can be used to re-create everything from the scaly skin of a snake to the soft, fluffy fur of a bunny. But before you attempt to render animal textures (shown on page 6), it's a good idea to get to know your tools and the variety of strokes you can make. On this page, you'll learn a number of shading techniques, as well as how to make a two-dimensional drawing appear three-dimensional.

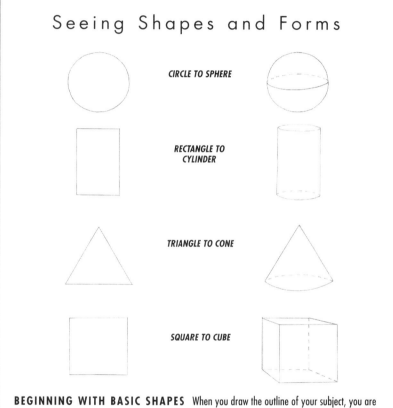

Seeing Shapes and Forms

CIRCLE TO SPHERE

RECTANGLE TO CYLINDER

TRIANGLE TO CONE

SQUARE TO CUBE

BEGINNING WITH BASIC SHAPES When you draw the outline of your subject, you are drawing its *shape*. But your subject also has depth and dimension, or *form*. The corresponding forms of the four basic shapes—circles, rectangles, squares, and triangles—are spheres, cylinders, cubes, and cones. Use ellipses to show the backs of the circle, cylinder, and cone, and draw a cube by connecting two squares with parallel lines. Once you've learned to sketch the basic shapes and develop their forms, you'll be able to draw any subject just by connecting and refining lines!

BUILDING UP FORMS

Values tell us even more about a form than its outline. *Value* is the basic term used to describe the relative lightness or darkness of a color or of black (as in pencil drawing). In pencil drawing, the values range from white to grays to black, and it's the variation among lights and darks (made with shading) and the range of values in shadows and highlights that give a three-dimensional look to a two-dimensional drawing. Once you've established the general shape and form of the subject using basic shapes, refine your drawing by applying lights and darks. Adding values through shading allows you to further develop form and give depth to your subject, making it really seem to come to life on paper!

A basic method of shading is to fill an area with hatching (a series of parallel strokes).

For darker shading, go over your hatching with a perpendicular set of hatch marks.

SHADING DARKLY

By applying heavy pressure to the pencil, you can create dark, linear areas of shading.

BLENDING

For smoother shading, rub a blending stump over heavily shaded areas to blend the strokes.

SHADING WITH TEXTURE

To fill in any area with mottled texture, use the side of the pencil tip and apply small, uneven strokes.

GRADATING

Create a gradation of dark to light by stroking from heavy to light pressure with the side of the pencil.

SHAPE

FORM

SHADING TO CREATE FORM Shading is the key to transforming simples shapes into convincing three-dimensional forms. Apply less pressure for lighter values and more pressure for darker values. And as you shade, keep in mind the direction of the light source and where it creates highlights and shadows. On round objects, pay careful attention to the edge closest to the cast shadow; this area is lightened by *reflected light*, which bounces up from the ground surface.

Creating Animal Textures

SMOOTH SCALES

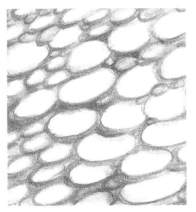

To depict smooth scales, first draw ovals of various sizes; then shade between them. Because scales overlap, be sure to partially cover each scale with the next layer.

ROUGH SCALES

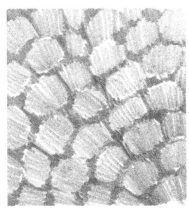

For rough scales, create irregular shapes that follow a slightly curved alignment. Shade darkly between the shapes; then shade over them with light, parallel strokes.

FINE FEATHERS

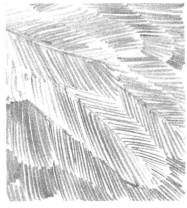

For light, downy feathers, apply thin, parallel lines along the feather stems, forming a series of V shapes. Avoid crisp outlines, which would take away from the softness.

HEAVY FEATHERS

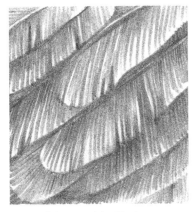

To create thicker, more defined feathers, use heavier parallel strokes and blend with a tortillon. Apply the most graphite to the shadowed areas between the feathers.

SHORT HAIR

To create a shiny, short-haired hide, apply short, straight strokes with the broad side of the pencil. For subtle wrinkles, add a few horizontal strips that are lighter in value.

WAVY HAIR

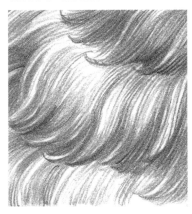

For layers of soft curls, stroke in S-shaped lines that end in tighter curves. Leave the highlights free of graphite and stroke with more pressure as you move to the shadows.

ROUGH COAT

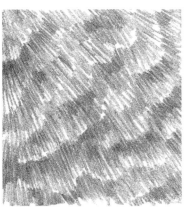

For a subtle striped pattern, apply short strokes in the direction of fur growth. Then apply darker strokes in irregular horizontal bands. Pull out highlights with an eraser.

SMOOTH COAT

For a smooth, silky coat, use sweeping parallel pencil strokes, leaving the highlighted areas free of graphite. Alternate between the pencil tip and the broad side for variation.

CURLY HAIR

Curly, wooly coats can be drawn with overlapping circular strokes of varying values. For realism, draw curls of differing shapes and sizes and blend for softness.

LONG HAIR

To render long hair—whether it's the whole coat or just a mane or tail—use longer, sweeping strokes that curve slightly, and taper the hairs to a point at the ends.

WHISKERS

To suggest whiskers, first apply rows of dots on the animal's cheek. Fill in the fur as you have elsewhere; then, with the tip of a kneaded eraser, lift out thin, curving lines.

NOSE

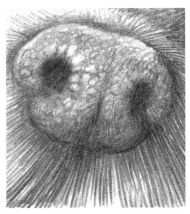

Most animal noses have a bumpy texture that can be achieved with a very light scale pattern. Add a shadow beneath the nose; then pull out highlights with a kneaded eraser.

Drawing from Photos

Pets are always on the move, which means these captivating subjects can be challenging to draw from life. To capture a fleeting pose—as well as the lighting and color of the moment—you may choose to work from photos. Always snap photographs from different angles and under different lighting to give yourself plenty of choices for your drawing—or use your *artistic license* to combine several references to complete one drawing. Don't ever feel as if you have to be a slave to any given reference; artistic license allows you to alter the composition—or even the subject itself—however you please! For instance, you may use one photo as a reference for the pose, another for the texture of the fur, and your memory for the shape of the eye. It's all up to you!

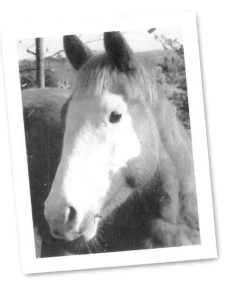

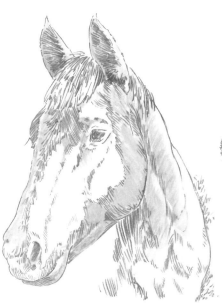

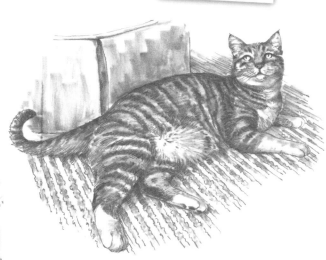

COPYING A PORTRAIT This drawing was based on the photo reference shown above. It captured the noble gaze and chiseled physical characteristics of this particular horse. Because the photo was so clear, the drawing follows it faithfully—aside from a small bit of artistic license I took to give the bluntly cut forelock a more natural look.

COMBINING REFERENCES I used two reference photos to complete the drawing above. The photo of the reclining cat clearly shows the animal's pose—providing a great reference for the cat's shape and proportions. But I referred to the second photo for a better view of the details, including the cat's facial features and the texture of its fur.

Creating an Artist's Morgue

The more skilled you become at drawing and the more different animals appeal to you as subjects, the more references you'll want to have on hand. Many artists keep some type of file for storing images, also called an "artist's morgue." This system of collecting film prints, slides, and digital images can supplement the information you note in your sketchbook, such as the color, texture, or proportions of a subject. You may also want to include magazine clippings, postcards, or other visual materials in your file, but be sure to use these items as loose references for general information only; replicating another's work without permission is a copyright infringement.

Artists today are fortunate to have many means of obtaining and cataloging pictures. You can store thousands of photos on CDs, and each picture can be pulled up on screen in a matter of seconds. If you choose to create physical folders, you might want to file your images alphabetically by subject so they are easily accessible when the need for a reference arises. And you can use all forms of storage for your artist's morgue—you can even print still-frame shots from your own animal videos.

Guinea Pig

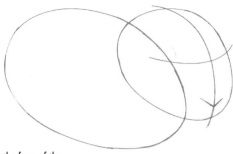

1 I start by establishing the form of the head and body with two overlapping egg shapes. Then I draw a few guidelines for the features, dividing the 3/4-view face into quadrants and adding a V for the nose.

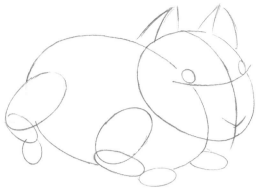

2 Next I establish the underlying structure, indicating the legs and paws with a series of ovals. I add the position of the ears and place the eyes just above the horizontal guideline.

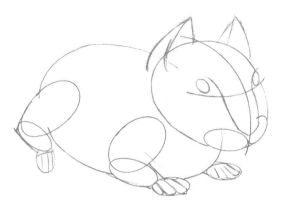

3 Now I begin to define the individual toes on the paws. I also suggest the shape of the nasal area with a U-shaped line, and I use small ovals to define the cheek pouches.

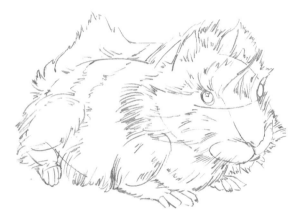

4 I begin to render the thick, furry coat around the basic structure I've already established, applying short strokes of varying thicknesses. It's much easier to work out the direction of fur growth and the overall shape of the animal when you know what is underneath.

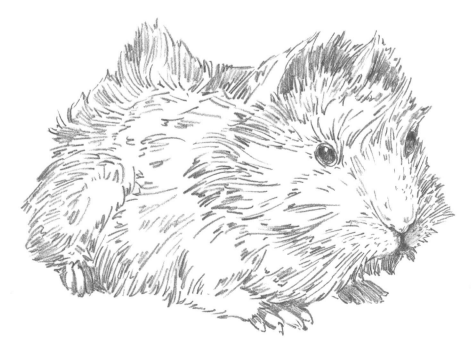

5 Next I erase any guidelines that I don't need and continue to develop the fur. With the broad side of a pencil, I stroke light shadows around the edges of the guinea pig to suggest its roundness. I keep the drawing simple because the guinea pig's shape is rather vague; I concentrate instead on suggesting the tufts of fur.

Bichon Frise

1 Using a 2B pencil, I begin the drawing with two circles: one for the head and one for the muzzle. Then I draw a few guidelines to establish the centerline of the face, which will help me determine feature placement.

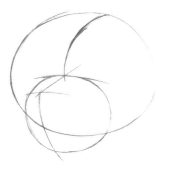

2 Now I place the facial features, including the eyes, nose, and mouth. I also draw two long ovals for ears. Notice that the eye closest to the viewer appears to be slightly larger than the eye that is farther away— this is an example of *foreshortening*.

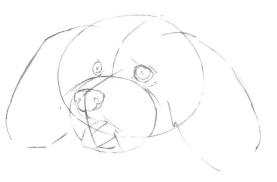

3 Next I use the shapes from the previous steps to create a general outline of the dog's curly fur with scribbled, squiggly lines. Using the same technique, I suggest the ears, ruff, and muzzle.

4 Now I erase the initial guidelines that I don't need. I also begin to refine the eyes and muzzle area, developing the darks with thick, closely placed strokes that follow the direction of fur growth.

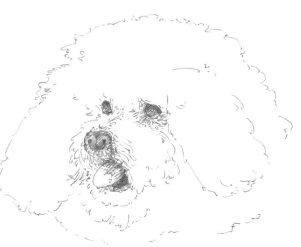

5 To finish, I further develop the coat with scribbles to suggest the frizzy texture of the hair. You don't have to render each individual strand of hair— just give the general impression of the overall texture. I am very loose with my pencil to give the drawing a playful and spontaneous feel. To finish, I smudge a few areas with a cotton swab to create subtle shadows.

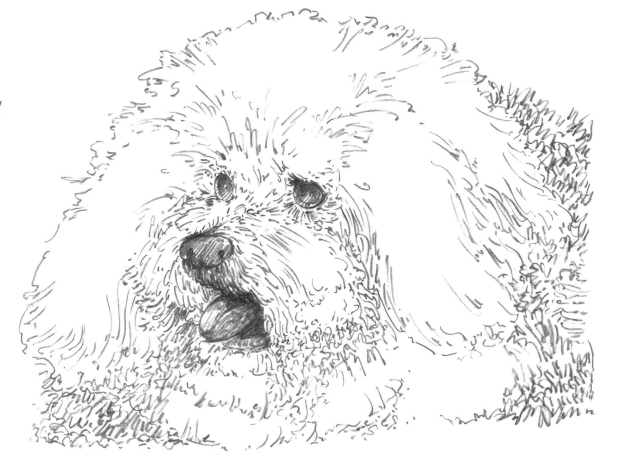

Domestic Short-Hair Cat

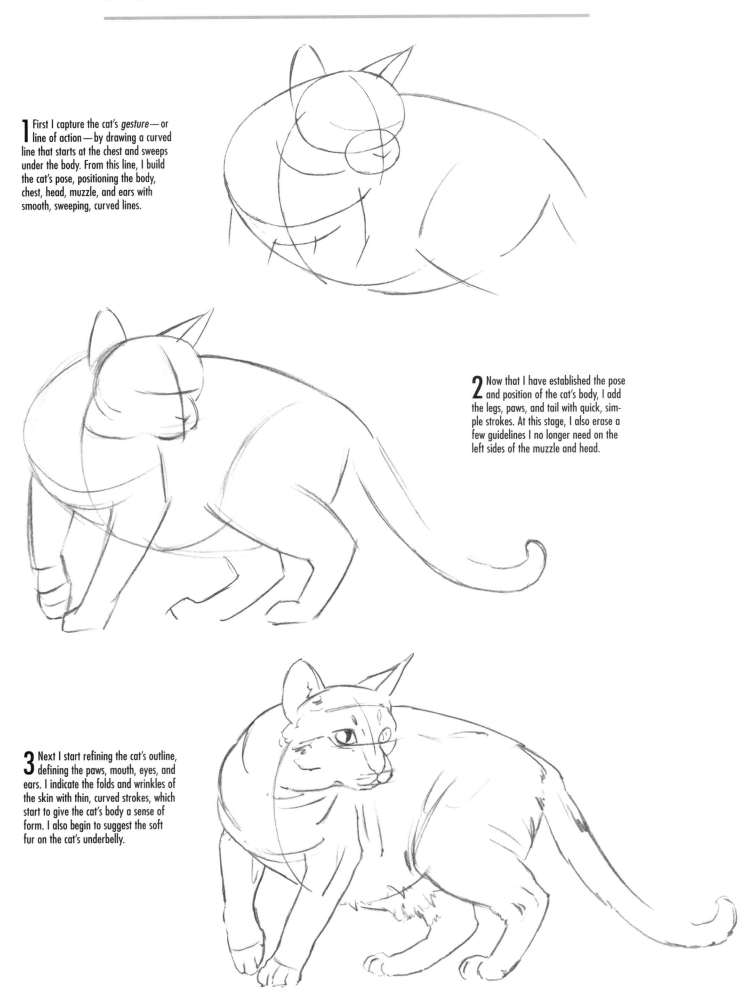

1 First I capture the cat's *gesture*—or line of action—by drawing a curved line that starts at the chest and sweeps under the body. From this line, I build the cat's pose, positioning the body, chest, head, muzzle, and ears with smooth, sweeping, curved lines.

2 Now that I have established the pose and position of the cat's body, I add the legs, paws, and tail with quick, simple strokes. At this stage, I also erase a few guidelines I no longer need on the left sides of the muzzle and head.

3 Next I start refining the cat's outline, defining the paws, mouth, eyes, and ears. I indicate the folds and wrinkles of the skin with thin, curved strokes, which start to give the cat's body a sense of form. I also begin to suggest the soft fur on the cat's underbelly.

4 After I erase the guidelines from the face and underbelly, I begin developing the texture of the coat. I use thin, straight strokes that follow the direction of the hair and the form of the body. In shadowed areas, such as the ear, underbelly, and far hind leg, I apply denser strokes.

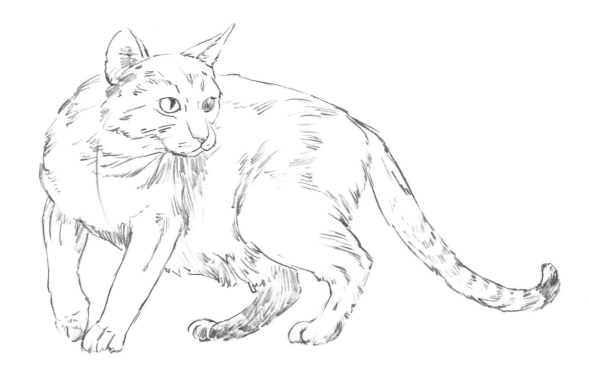

5 I continue developing the coarse texture of the coat with dark, unblended strokes of pencil. I use shorter strokes for areas with shorter hair (such as the face and chest) and longer strokes to represent longer hair (such as the underbelly and ears). Finally I add the whiskers and fill in the eyes, leaving a few small white highlights.

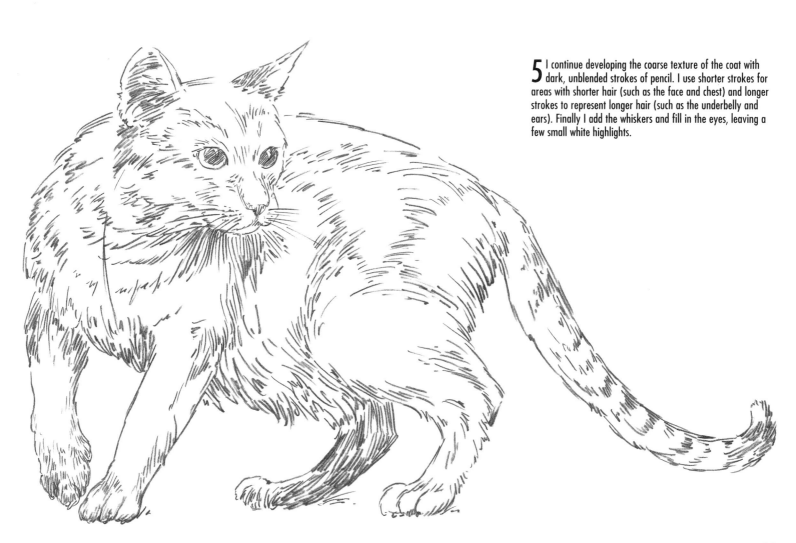

Ferret

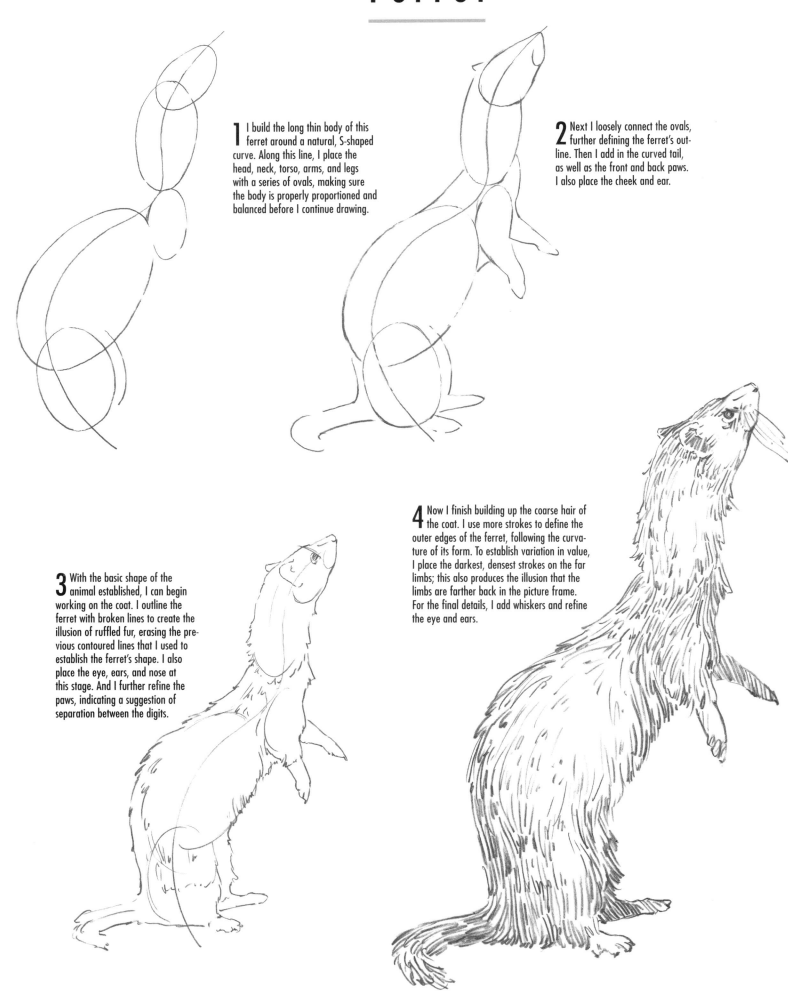

1 I build the long thin body of this ferret around a natural, S-shaped curve. Along this line, I place the head, neck, torso, arms, and legs with a series of ovals, making sure the body is properly proportioned and balanced before I continue drawing.

2 Next I loosely connect the ovals, further defining the ferret's outline. Then I add in the curved tail, as well as the front and back paws. I also place the cheek and ear.

3 With the basic shape of the animal established, I can begin working on the coat. I outline the ferret with broken lines to create the illusion of ruffled fur, erasing the previous contoured lines that I used to establish the ferret's shape. I also place the eye, ears, and nose at this stage. And I further refine the paws, indicating a suggestion of separation between the digits.

4 Now I finish building up the coarse hair of the coat. I use more strokes to define the outer edges of the ferret, following the curvature of its form. To establish variation in value, I place the darkest, densest strokes on the far limbs; this also produces the illusion that the limbs are farther back in the picture frame. For the final details, I add whiskers and refine the eye and ears.

Doberman Pinscher

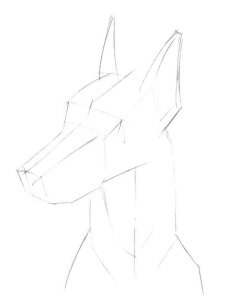

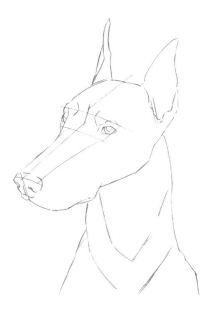

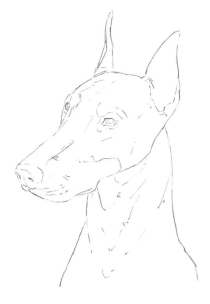

1 With a sharp HB pencil, I establish the boxy shape of the Doberman's head and shoulders with quick, straight lines. Even at this early stage, I'm establishing a sense of dimension and form, which I'll build upon as the drawing progresses.

2 Using the lines from the previous step as a guide, I adjust the outline of the ears, head, and neck to give them a more contoured appearance. I also add the eyes and nose, following the facial guidelines. Finally I refine the outline of the muzzle.

3 Next I erase any guidelines that are no longer needed. Then I begin placing light, broken lines made up of short dashes to indicate where the value changes in the coat are. These initial lines will act as a map for later shading.

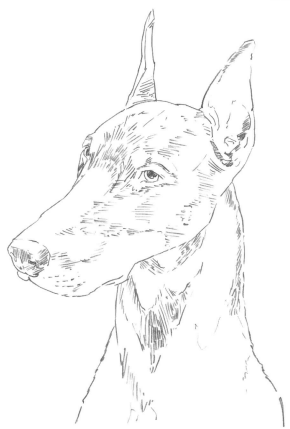

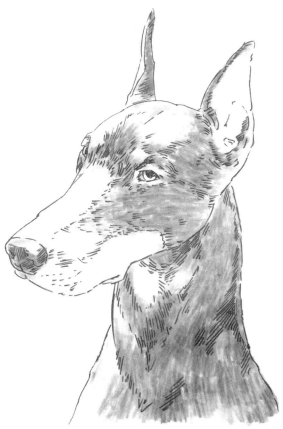

4 For the dog's short hair, I begin with small, dark hatch marks to establish the bristly, coarse nature of the coat. I also fill in the darks of the eyes and eyebrows, and I dot in a few light rows of whiskers at the tip of the muzzle.

5 To finish, I fill in the remaining darks of the coat. First I create graphite dust by rubbing a pencil over a sheet of fine sandpaper. Then I pick up the graphite dust with a medium-sized blending stump and shade in the dark areas of the dog's fur and nose. To avoid hard edges, I blend to create soft gradations where the two values meet.

Horse

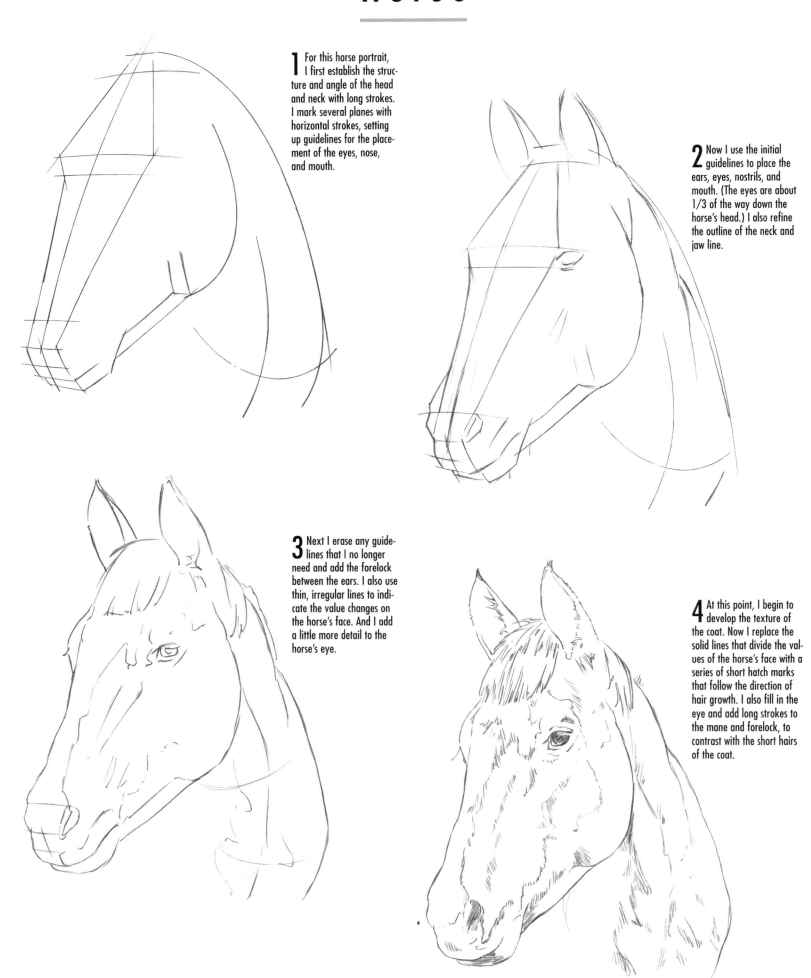

1 For this horse portrait, I first establish the structure and angle of the head and neck with long strokes. I mark several planes with horizontal strokes, setting up guidelines for the placement of the eyes, nose, and mouth.

2 Now I use the initial guidelines to place the ears, eyes, nostrils, and mouth. (The eyes are about 1/3 of the way down the horse's head.) I also refine the outline of the neck and jaw line.

3 Next I erase any guidelines that I no longer need and add the forelock between the ears. I also use thin, irregular lines to indicate the value changes on the horse's face. And I add a little more detail to the horse's eye.

4 At this point, I begin to develop the texture of the coat. Now I replace the solid lines that divide the values of the horse's face with a series of short hatch marks that follow the direction of hair growth. I also fill in the eye and add long strokes to the mane and forelock, to contrast with the short hairs of the coat.

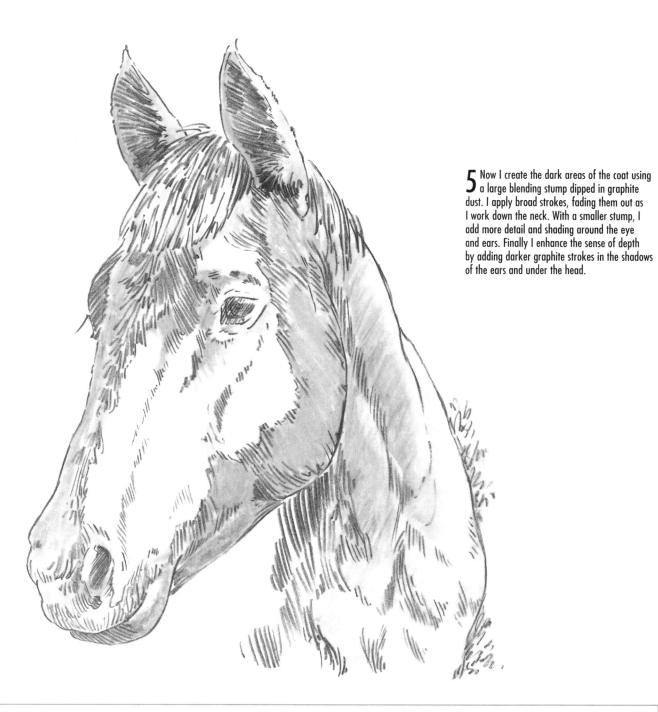

5 Now I create the dark areas of the coat using a large blending stump dipped in graphite dust. I apply broad strokes, fading them out as I work down the neck. With a smaller stump, I add more detail and shading around the eye and ears. Finally I enhance the sense of depth by adding darker graphite strokes in the shadows of the ears and under the head.

Horse Details

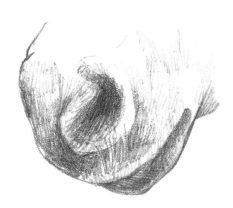

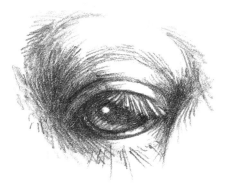

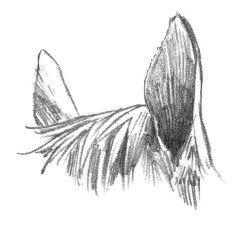

MUZZLE The muzzle has subtle, curved forms, which I define with careful shading. The area around the nostril is raised, as is the area just above the mouth; I indicate this by pulling out highlights with a kneaded eraser.

EYE Horses' eyes have a lot of detail, from the creases around the eyes to the straight, thick eyelashes that protect them. To create a sense of life in the eye, leave a light crescent-shaped area to show reflected light, and leave a stark white highlight above it.

EARS I render the horse's forelock hair with long, slightly curving strokes. Then I shade the interior of the ear with upward, parallel strokes, making them darkest at the bottom and gradually lighter as I move up the ear.

Parrot

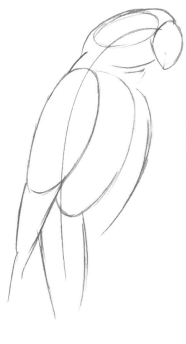

1 First I establish the overall pose by drawing a long, curved arc from the parrot's beak to its tail with an HB pencil. On this centerline, I place the beak and build the head, chest, wings, and tail with ovals and tapering lines.

2 Now that the basic form of the body exists, I place the feet and add a perch to "ground" the parrot. I also draw the eye and refine the outline of the beak, defining the upper and bottom parts.

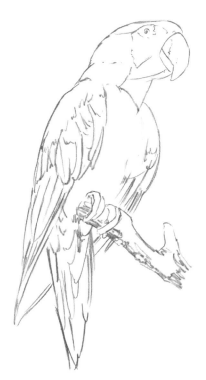

3 Next I erase any unnecessary guidelines. I give the perch some form by scribbling shadows along the lower and left edges. Then I continue to refine outlines, indicating the separations between the most pronounced feathers on a parrot's body: the wing and tail feathers.

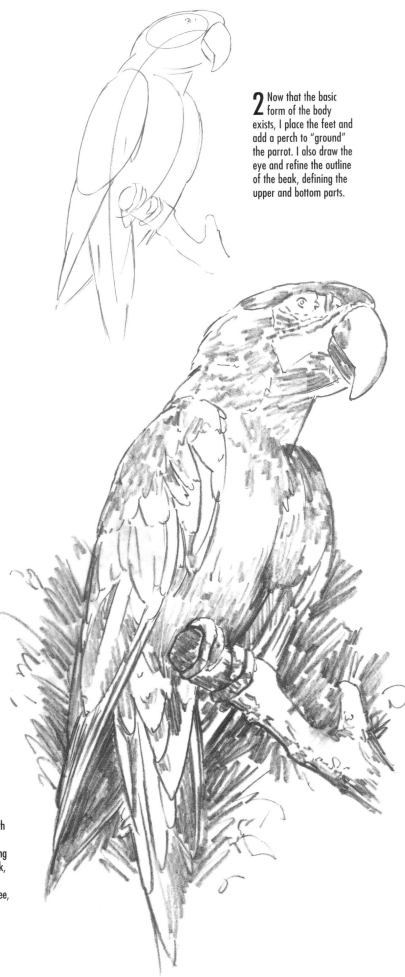

4 Parrots are known for their dramatic coloring, so I convey this with bold, broad pencil strokes. I shade mainly along the edges of the bird to build form, filling in some feathers with soft strokes and leaving others white. To make the bird stand out from the paper, I apply quick, expressive strokes that radiate from the bird's body. I want the background to capture the liveliness of the bird's character too, so I use free, loose strokes and scribbles to convey spontaneity and dynamism.

Rabbit

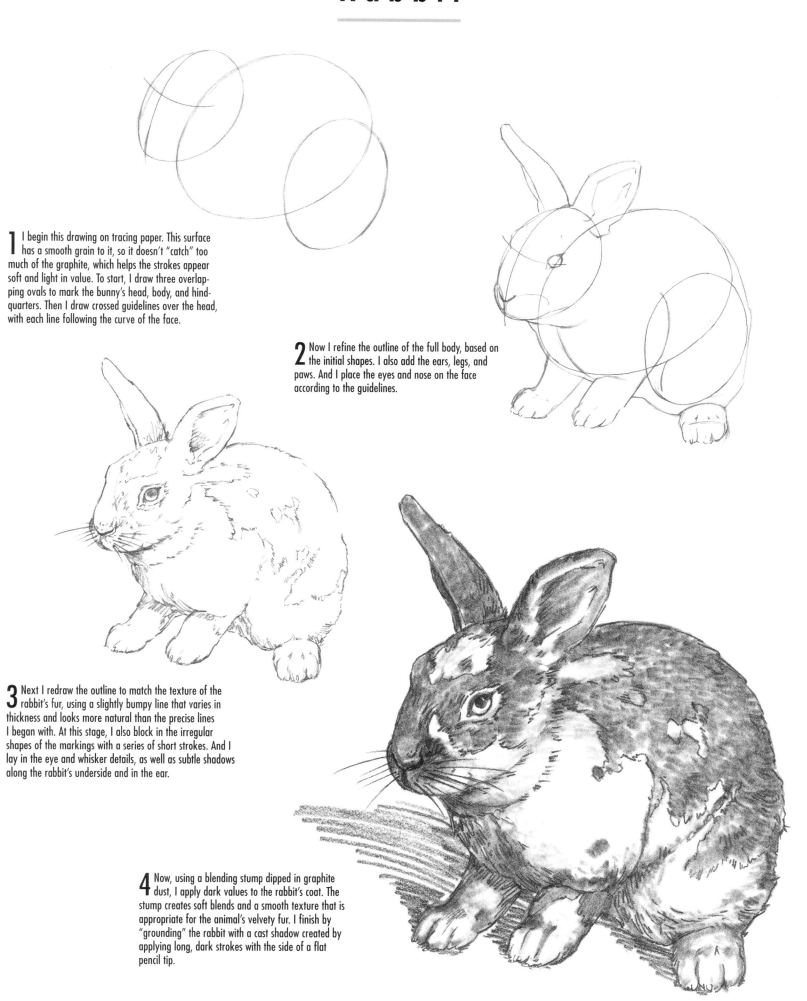

1 I begin this drawing on tracing paper. This surface has a smooth grain to it, so it doesn't "catch" too much of the graphite, which helps the strokes appear soft and light in value. To start, I draw three overlapping ovals to mark the bunny's head, body, and hindquarters. Then I draw crossed guidelines over the head, with each line following the curve of the face.

2 Now I refine the outline of the full body, based on the initial shapes. I also add the ears, legs, and paws. And I place the eyes and nose on the face according to the guidelines.

3 Next I redraw the outline to match the texture of the rabbit's fur, using a slightly bumpy line that varies in thickness and looks more natural than the precise lines I began with. At this stage, I also block in the irregular shapes of the markings with a series of short strokes. And I lay in the eye and whisker details, as well as subtle shadows along the rabbit's underside and in the ear.

4 Now, using a blending stump dipped in graphite dust, I apply dark values to the rabbit's coat. The stump creates soft blends and a smooth texture that is appropriate for the animal's velvety fur. I finish by "grounding" the rabbit with a cast shadow created by applying long, dark strokes with the side of a flat pencil tip.

Siberian Husky Puppy

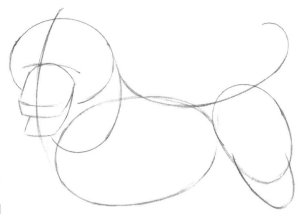

1 First I suggest the position of the spine and tail with one gently curving gesture line. Then I use this line to position the round shape of the head, body, and hindquarters. I also draw guidelines for the pup's facial features, at the same time establishing the general shape of the muzzle.

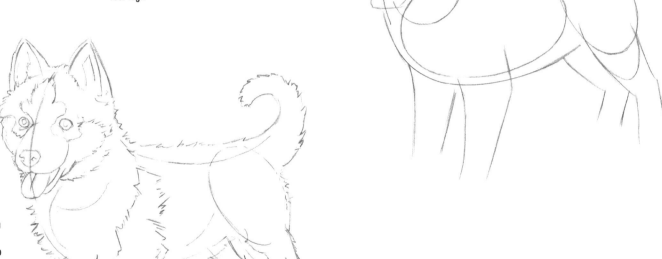

2 Now I outline the complete torso using smooth, quick lines based on the initial shapes. I also place the triangular ears and suggest the upper portion of the four legs.

3 Once I'm satisfied with the pose and the way it's taken shape, I begin to develop the puppy's coat. I apply a series of short, parallel strokes that follow the previous outline, producing the appearance of a thick coat. Using the same kind of strokes, I outline the color pattern of the coat. I also place the eyes, nose, mouth, and tongue, and I refine the paws.

4 Next I erase any guidelines that I don't need and begin shading the dark areas of the fur with the broad side of my pencil. I use straight strokes that follow the direction of hair growth, radiating from the center of the face and chest. I also shade in the nose and pupils. Then I add a background to contrast with the white of the puppy's chest. I apply broad strokes with the side of the pencil in straight, horizontal lines.

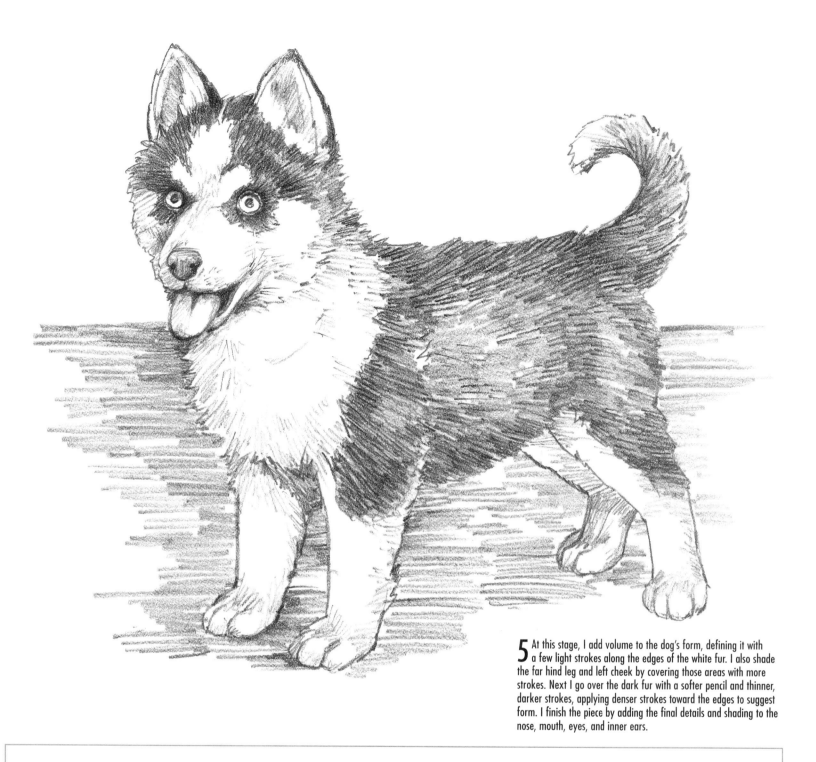

5 At this stage, I add volume to the dog's form, defining it with a few light strokes along the edges of the white fur. I also shade the far hind leg and left cheek by covering those areas with more strokes. Next I go over the dark fur with a softer pencil and thinner, darker strokes, applying denser strokes toward the edges to suggest form. I finish the piece by adding the final details and shading to the nose, mouth, eyes, and inner ears.

Comparing the Puppy and the Dog

Young puppies and full-sized dogs have the same features but in different proportions. *Proportion* refers to the proper relation of one part to another or to the whole—particularly in terms of size or shape—and it is a key factor in achieving a good likeness. A puppy isn't just a small dog. Although a puppy has all the same parts as its adult counterpart, the puppy's body appears more compact than the dog's—and its paws, ears, and eyes seem much larger in proportion to the rest of its body. In contrast, the adult dog seems longer, leaner, and taller. Its muzzle appears larger in proportion to the rest of its body, and its teeth are noticeably bigger. Keeping these proportional differences in mind and incorporating them in your drawings will help you make your artwork look convincing.

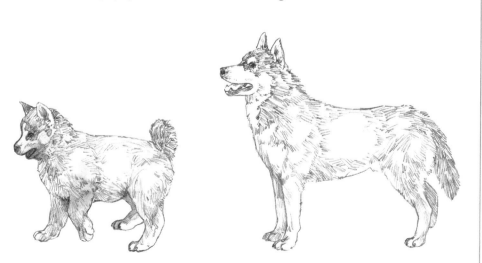

Ragdoll Kittens

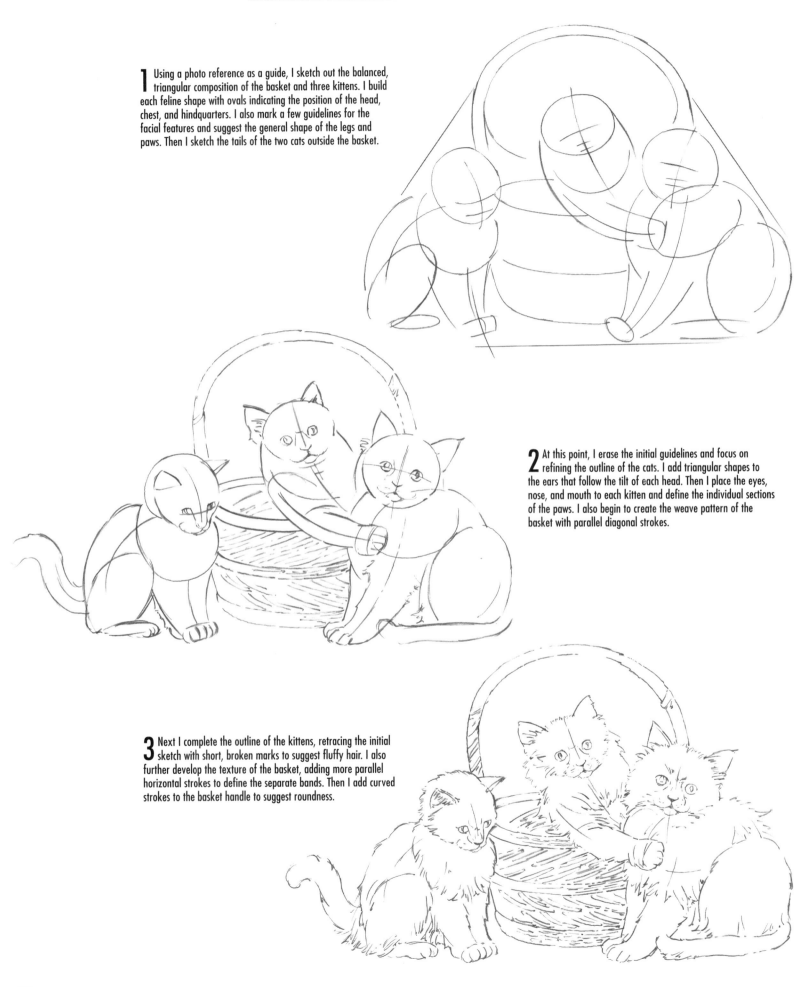

1 Using a photo reference as a guide, I sketch out the balanced, triangular composition of the basket and three kittens. I build each feline shape with ovals indicating the position of the head, chest, and hindquarters. I also mark a few guidelines for the facial features and suggest the general shape of the legs and paws. Then I sketch the tails of the two cats outside the basket.

2 At this point, I erase the initial guidelines and focus on refining the outline of the cats. I add triangular shapes to the ears that follow the tilt of each head. Then I place the eyes, nose, and mouth to each kitten and define the individual sections of the paws. I also begin to create the weave pattern of the basket with parallel diagonal strokes.

3 Next I complete the outline of the kittens, retracing the initial sketch with short, broken marks to suggest fluffy hair. I also further develop the texture of the basket, adding more parallel horizontal strokes to define the separate bands. Then I add curved strokes to the basket handle to suggest roundness.

4 I continue to add texture to the basket and the kittens, switching between an H and a 2B pencil. I also vary the thickness of each stroke by alternating between the sharp point and the flat side of the pencil lead. As I develop each area, I'm careful to do so at the same rate to maintain an even balance.

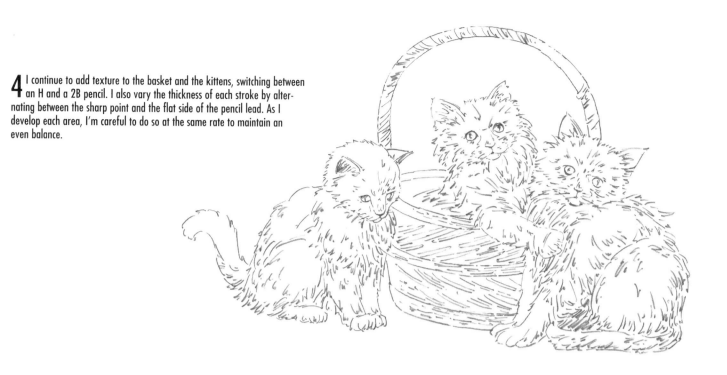

5 To finish, I darken the basket shadows by stroking over them with the flat side of the pencil tip, following the direction of previously placed strokes. I use the same technique to add cast shadows under the kittens and basket. These dark areas will contrast nicely with the white highlights on the kittens. To finish the kittens' coats, I lightly shade with a blending stump to produce softer, more subtle shadows.

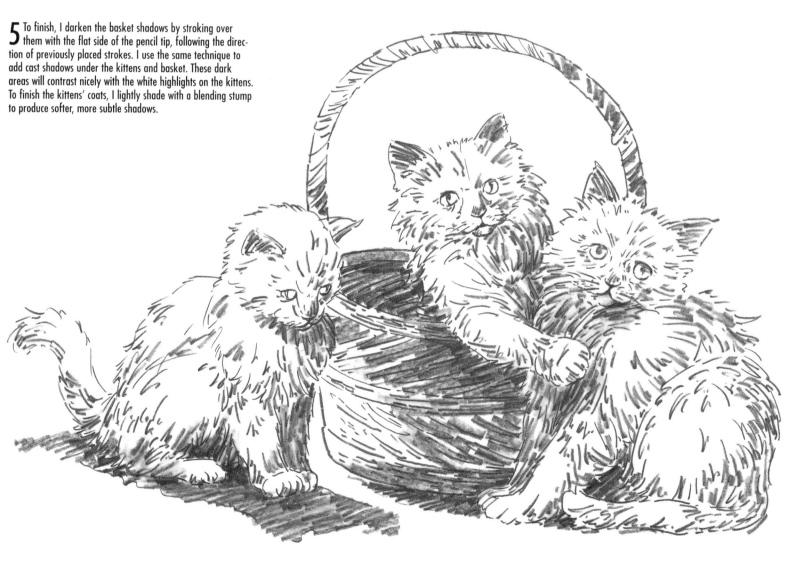

P o n y

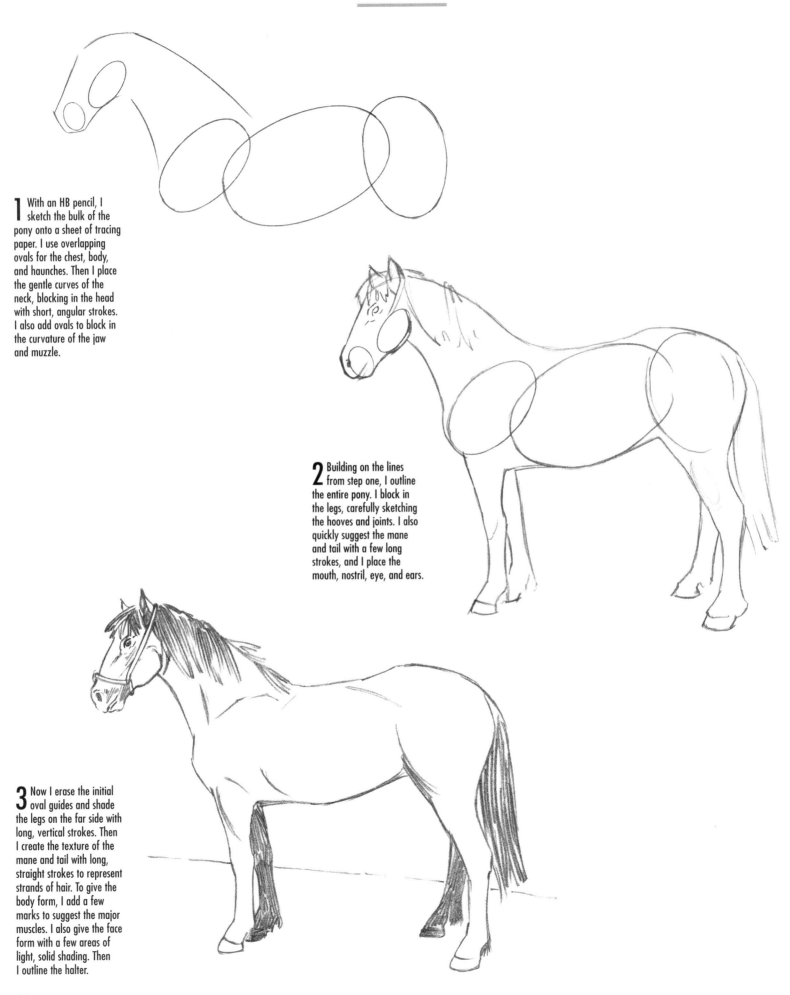

1 With an HB pencil, I sketch the bulk of the pony onto a sheet of tracing paper. I use overlapping ovals for the chest, body, and haunches. Then I place the gentle curves of the neck, blocking in the head with short, angular strokes. I also add ovals to block in the curvature of the jaw and muzzle.

2 Building on the lines from step one, I outline the entire pony. I block in the legs, carefully sketching the hooves and joints. I also quickly suggest the mane and tail with a few long strokes, and I place the mouth, nostril, eye, and ears.

3 Now I erase the initial oval guides and shade the legs on the far side with long, vertical strokes. Then I create the texture of the mane and tail with long, straight strokes to represent strands of hair. To give the body form, I add a few marks to suggest the major muscles. I also give the face form with a few areas of light, solid shading. Then I outline the halter.

Parts of Horses and Ponies

You certainly don't need to learn the names of every bone and muscle in order to draw an animal accurately. But it is helpful to have a little knowledge of the basic anatomy of your subject. For example, an understanding of the underlying shapes of the horse's skeletal and musculature structures will result in more realistic depictions of the horse's form. (Ponies have the same basic structure as horses, although sizes and proportions differ.) Knowing the shapes of the bones will help you draw lifelike legs, hooves, and faces. And familiarity with the major muscle groups will help you place your shadows and highlights accurately, bringing the horse or pony's form to life.

Drawing the horse's body is easy if you break down the animal into basic shapes. Start with circles, cylinders, and trapezoids—as shown on the horse at right—to help you get a good general sense of the size and proportion of the parts of the horse, such as the head, neck, belly, and legs. Then simply connect these shapes, refine the lines, and add a few details to produce a realistic outline of your equine subject.

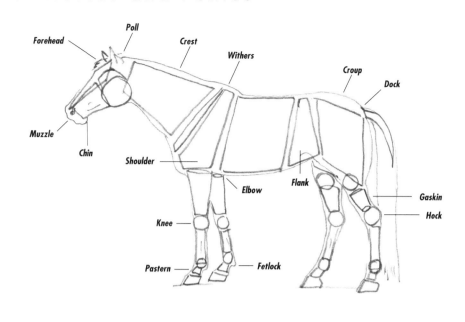

Artwork © 2005 Elin Pendleton.

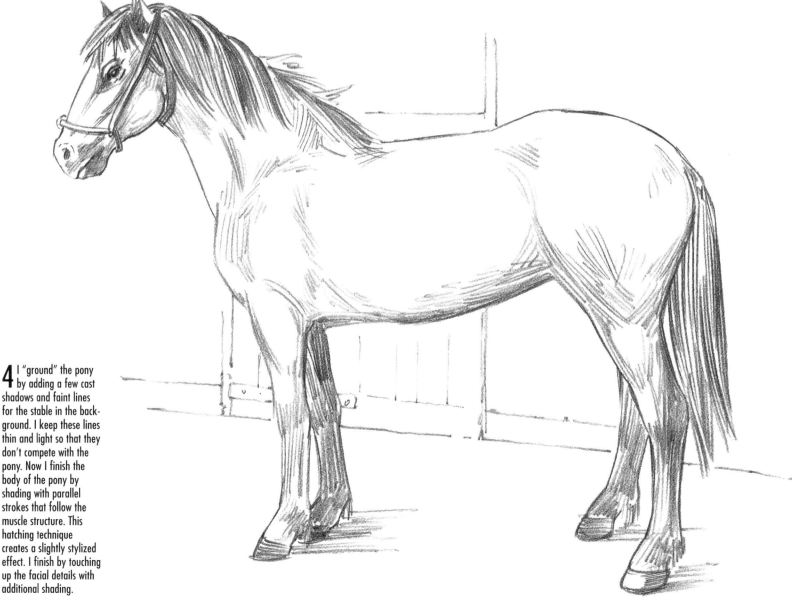

4 I "ground" the pony by adding a few cast shadows and faint lines for the stable in the background. I keep these lines thin and light so that they don't compete with the pony. Now I finish the body of the pony by shading with parallel strokes that follow the muscle structure. This hatching technique creates a slightly stylized effect. I finish by touching up the facial details with additional shading.

Golden Retriever

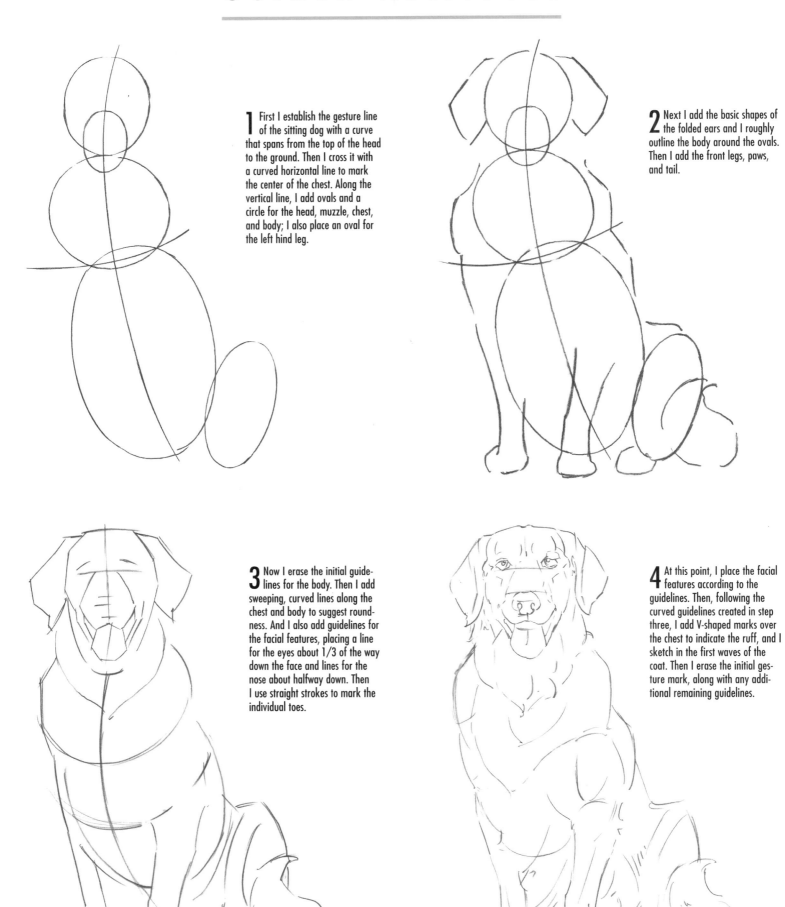

1 First I establish the gesture line of the sitting dog with a curve that spans from the top of the head to the ground. Then I cross it with a curved horizontal line to mark the center of the chest. Along the vertical line, I add ovals and a circle for the head, muzzle, chest, and body; I also place an oval for the left hind leg.

2 Next I add the basic shapes of the folded ears and I roughly outline the body around the ovals. Then I add the front legs, paws, and tail.

3 Now I erase the initial guidelines for the body. Then I add sweeping, curved lines along the chest and body to suggest roundness. And I also add guidelines for the facial features, placing a line for the eyes about 1/3 of the way down the face and lines for the nose about halfway down. Then I use straight strokes to mark the individual toes.

4 At this point, I place the facial features according to the guidelines. Then, following the curved guidelines created in step three, I add V-shaped marks over the chest to indicate the ruff, and I sketch in the first waves of the coat. Then I erase the initial gesture mark, along with any additional remaining guidelines.

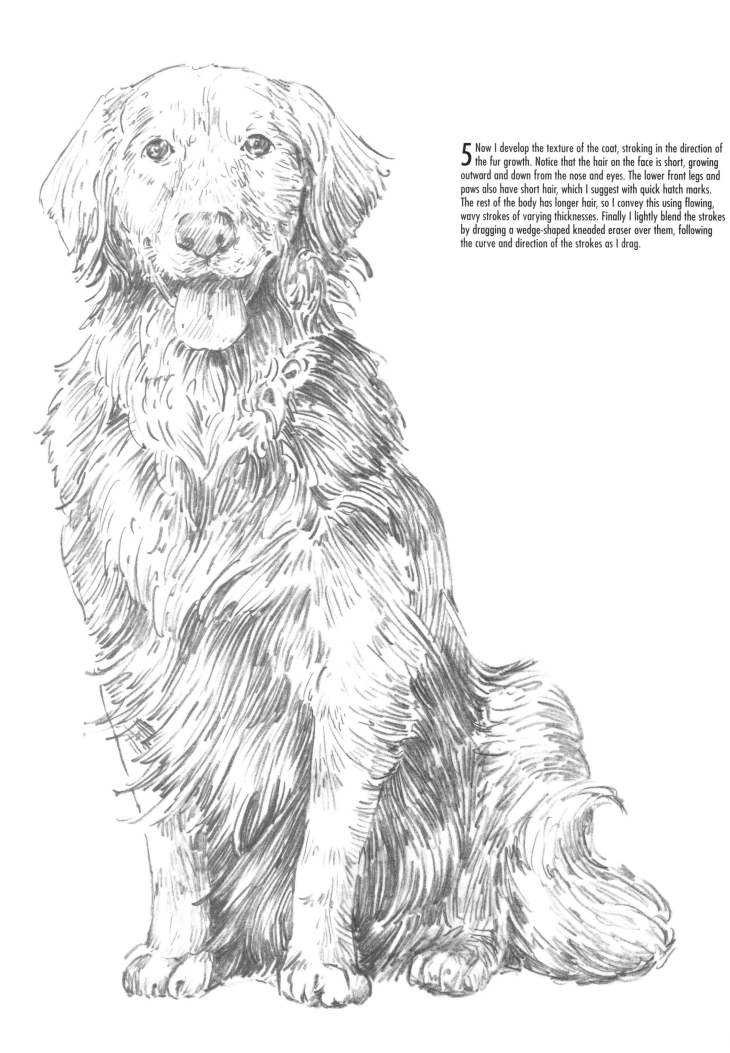

5 Now I develop the texture of the coat, stroking in the direction of the fur growth. Notice that the hair on the face is short, growing outward and down from the nose and eyes. The lower front legs and paws also have short hair, which I suggest with quick hatch marks. The rest of the body has longer hair, so I convey this using flowing, wavy strokes of varying thicknesses. Finally I lightly blend the strokes by dragging a wedge-shaped kneaded eraser over them, following the curve and direction of the strokes as I drag.

Snake

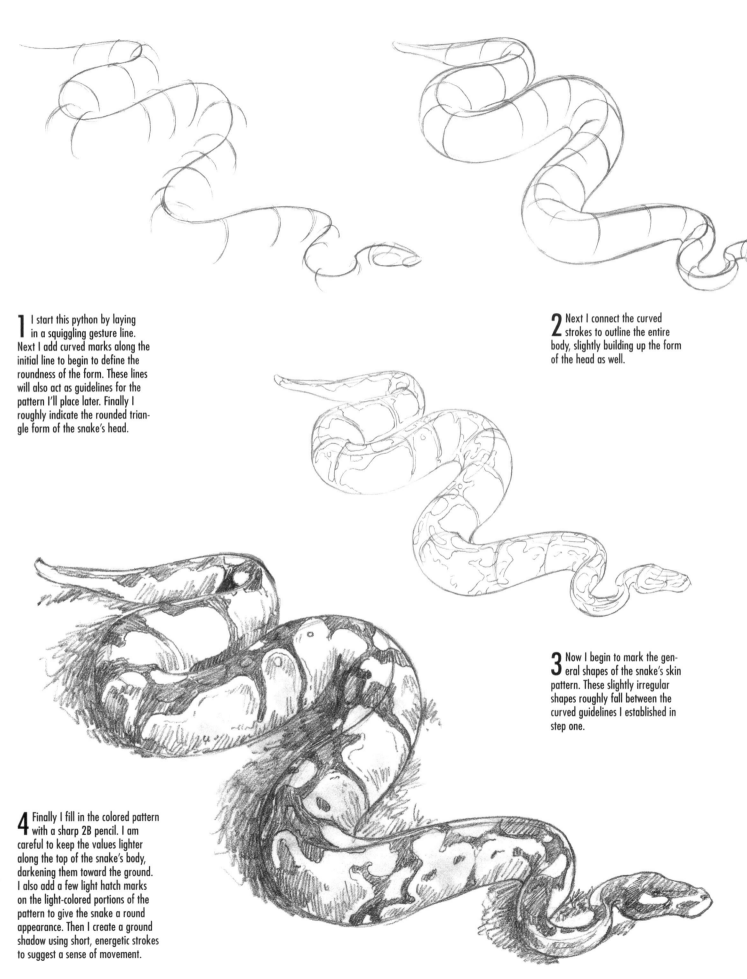

1 I start this python by laying in a squiggling gesture line. Next I add curved marks along the initial line to begin to define the roundness of the form. These lines will also act as guidelines for the pattern I'll place later. Finally I roughly indicate the rounded triangle form of the snake's head.

2 Next I connect the curved strokes to outline the entire body, slightly building up the form of the head as well.

3 Now I begin to mark the general shapes of the snake's skin pattern. These slightly irregular shapes roughly fall between the curved guidelines I established in step one.

4 Finally I fill in the colored pattern with a sharp 2B pencil. I am careful to keep the values lighter along the top of the snake's body, darkening them toward the ground. I also add a few light hatch marks on the light-colored portions of the pattern to give the snake a round appearance. Then I create a ground shadow using short, energetic strokes to suggest a sense of movement.

Tortoise

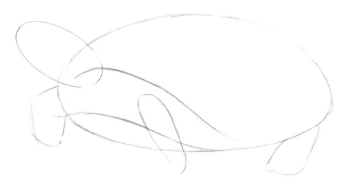

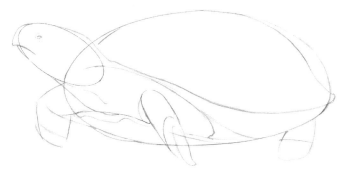

1 I begin by blocking in the basic shape of the tortoise. I use ovals for the body and head and then place the three visible legs. I also indicate the curves of the shell opening.

2 Now I refine the outline of the body, adding a slope to the back of the shell and a pointed beak to the face. I also place the eye and guidelines for the tortoise's toes.

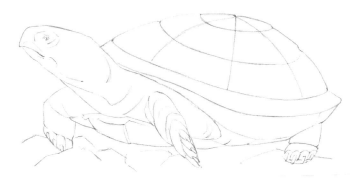

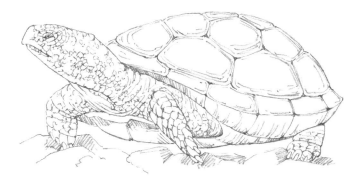

3 Next I erase any guidelines I no longer need before adding new guidelines for the shell pattern. Notice that the sections get bigger as the shell gets wider. Then I begin to add details to the tortoise's rough skin, suggesting some wrinkles, as well as the individual toes and claws. I ground the tortoise by placing it on an uneven, rocky surface.

4 Now I begin to create the texture of the tortoise's leathery skin. I draw small scales on the head and neck of the tortoise, and I use larger scales on the legs. To create variation in texture and value within the skin, I alternate between HB, 2B, and 4B pencils. I leave the skin free of scales for the areas with the most highlight. At this stage, I also add several curving folds at the base of the neck to depict the drooping skin. Then I refine the pattern of the shell and add parallel ridges on the edges of each irregular section.

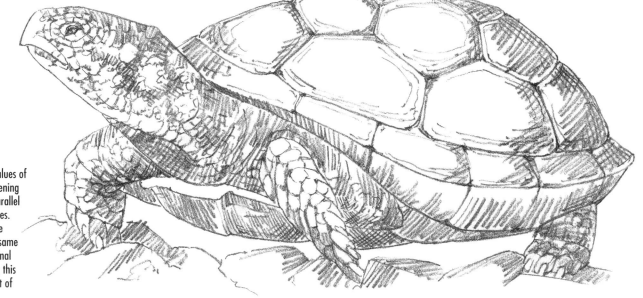

5 I further build up the values of the tortoise's skin, darkening the shadowed areas with parallel hatch marks and crosshatches. And I also further define the form of the shell using the same technique. Then I add the final touches to the face, making this detailed area the focal point of the drawing.

Tabby Cat

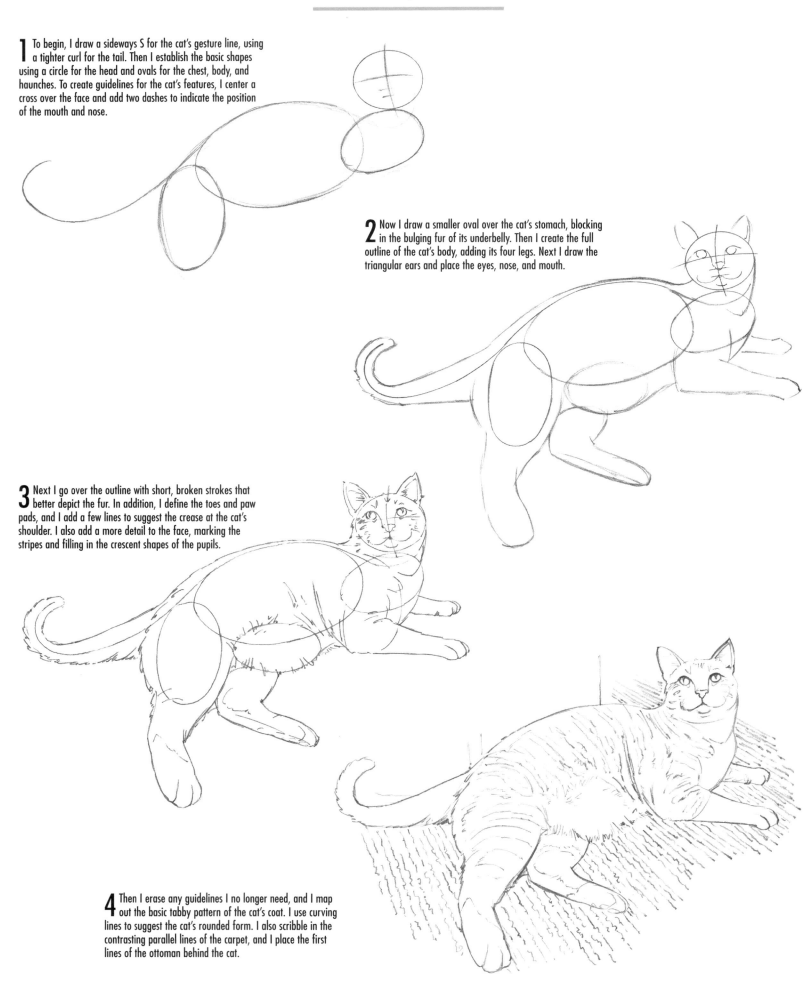

1 To begin, I draw a sideways S for the cat's gesture line, using a tighter curl for the tail. Then I establish the basic shapes using a circle for the head and ovals for the chest, body, and haunches. To create guidelines for the cat's features, I center a cross over the face and add two dashes to indicate the position of the mouth and nose.

2 Now I draw a smaller oval over the cat's stomach, blocking in the bulging fur of its underbelly. Then I create the full outline of the cat's body, adding its four legs. Next I draw the triangular ears and place the eyes, nose, and mouth.

3 Next I go over the outline with short, broken strokes that better depict the fur. In addition, I define the toes and paw pads, and I add a few lines to suggest the crease at the cat's shoulder. I also add a more detail to the face, marking the stripes and filling in the crescent shapes of the pupils.

4 Then I erase any guidelines I no longer need, and I map out the basic tabby pattern of the cat's coat. I use curving lines to suggest the cat's rounded form. I also scribble in the contrasting parallel lines of the carpet, and I place the first lines of the ottoman behind the cat.

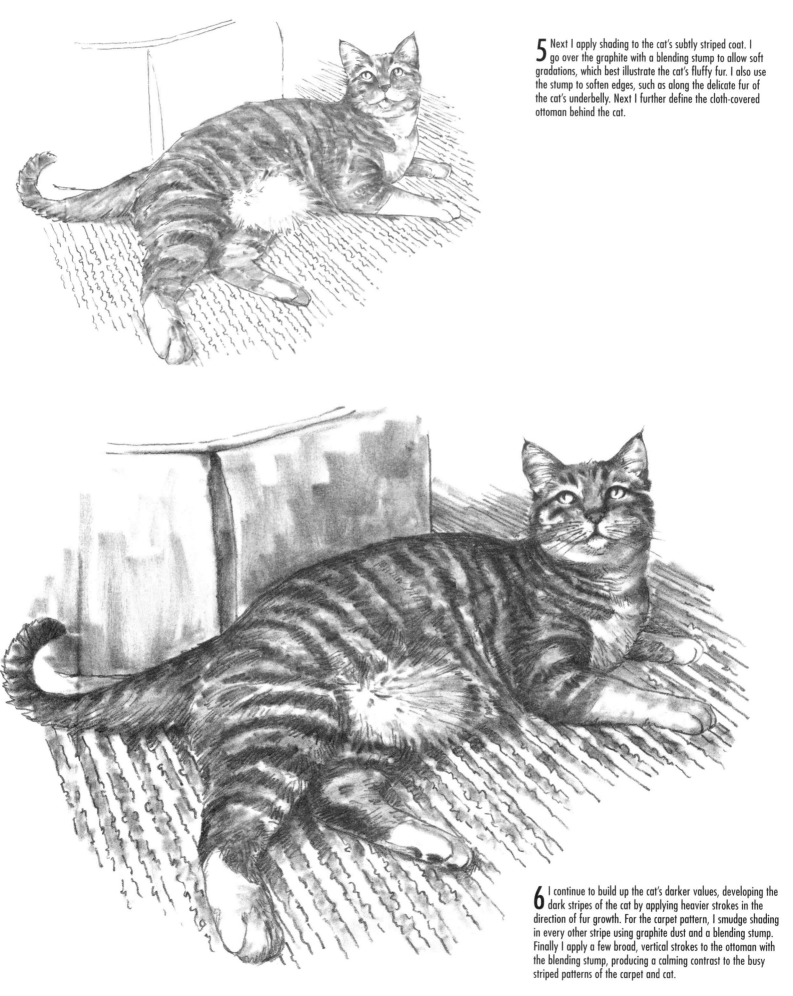

5 Next I apply shading to the cat's subtly striped coat. I go over the graphite with a blending stump to allow soft gradations, which best illustrate the cat's fluffy fur. I also use the stump to soften edges, such as along the delicate fur of the cat's underbelly. Next I further define the cloth-covered ottoman behind the cat.

6 I continue to build up the cat's darker values, developing the dark stripes of the cat by applying heavier strokes in the direction of fur growth. For the carpet pattern, I smudge shading in every other stripe using graphite dust and a blending stump. Finally I apply a few broad, vertical strokes to the ottoman with the blending stump, producing a calming contrast to the busy striped patterns of the carpet and cat.

Budgerigars

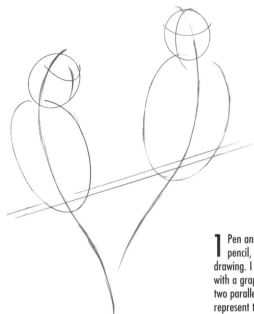

1 Pen and ink are wonderful adjuncts to pencil, and they let you create a bolder drawing. I begin this pen-and-ink drawing with a graphite pencil sketch. First I place two parallel lines diagonally on the paper to represent the perch. Then I draw the gesture line of each bird, and I place ovals to indicate the heads and bodies. The positions I choose form a heart-shaped composition.

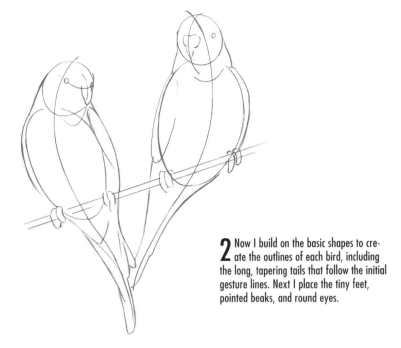

2 Now I build on the basic shapes to create the outlines of each bird, including the long, tapering tails that follow the initial gesture lines. Next I place the tiny feet, pointed beaks, and round eyes.

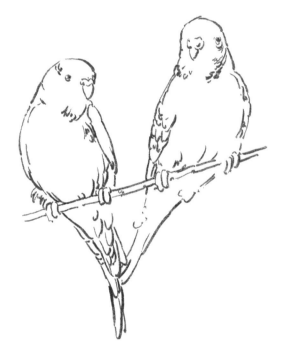

3 Now that I've created full outlines of the birds and established the placement of the most important details, I begin to apply ink. I use a brush pen loaded with ink to retrace the outline of each bird. I vary the thickness of my strokes by changing the amount of pressure on the brush, and I keep the strokes slightly broken to give the feathered outlines a natural look. I also begin to suggest the feathers with short, U-shaped strokes. When the ink dries completely, I erase my pencil guides.

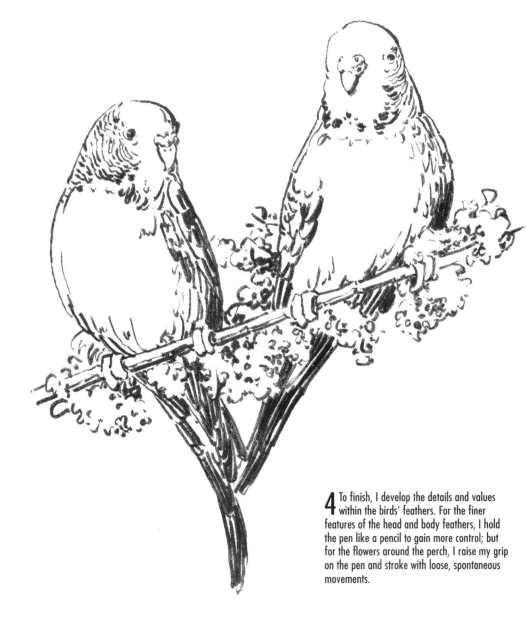

4 To finish, I develop the details and values within the birds' feathers. For the finer features of the head and body feathers, I hold the pen like a pencil to gain more control; but for the flowers around the perch, I raise my grip on the pen and stroke with loose, spontaneous movements.

Iguana

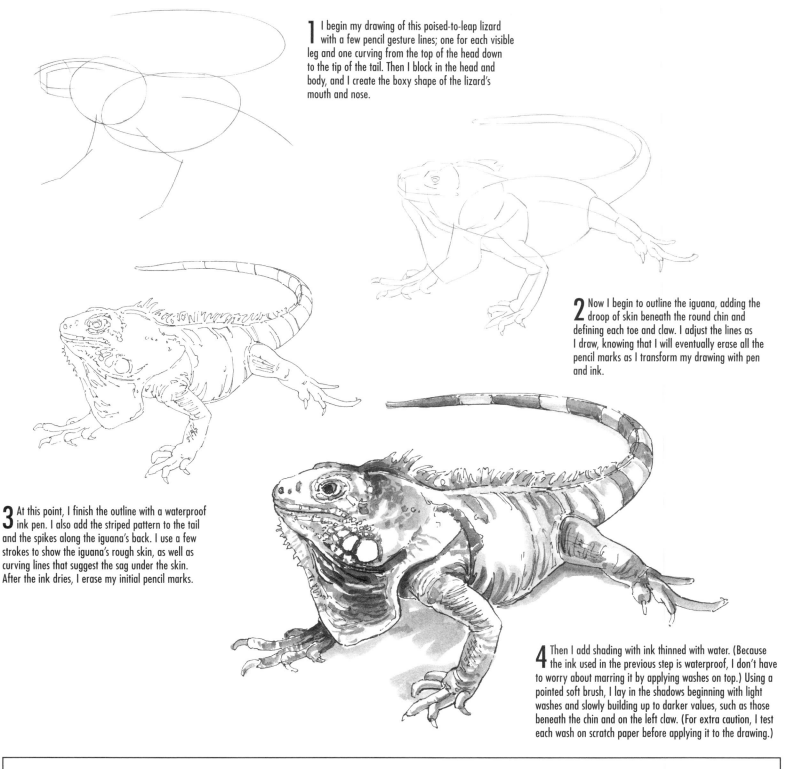

1 I begin my drawing of this poised-to-leap lizard with a few pencil gesture lines; one for each visible leg and one curving from the top of the head down to the tip of the tail. Then I block in the head and body, and I create the boxy shape of the lizard's mouth and nose.

2 Now I begin to outline the iguana, adding the droop of skin beneath the round chin and defining each toe and claw. I adjust the lines as I draw, knowing that I will eventually erase all the pencil marks as I transform my drawing with pen and ink.

3 At this point, I finish the outline with a waterproof ink pen. I also add the striped pattern to the tail and the spikes along the iguana's back. I use a few strokes to show the iguana's rough skin, as well as curving lines that suggest the sag under the skin. After the ink dries, I erase my initial pencil marks.

4 Then I add shading with ink thinned with water. (Because the ink used in the previous step is waterproof, I don't have to worry about marring it by applying washes on top.) Using a pointed soft brush, I lay in the shadows beginning with light washes and slowly building up to darker values, such as those beneath the chin and on the left claw. (For extra caution, I test each wash on scratch paper before applying it to the drawing.)

Varying Values with Ink Washes

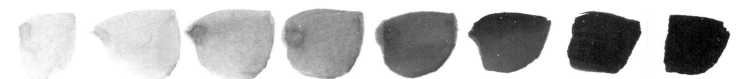

Simply adjusting the amount of water you use in your ink washes can provide a variety of different values. When creating a wash, it is best to start with the lightest value and build up to a darker wash, rather than adding water to a dark wash. To get acquainted with the process of mixing various values, create a value chart like the one above. Start with a very diluted wash at the left, and gradually add more pigment for successively darker values.

Walter Foster presents a new series

THE ART OF DRAWING

Bringing you quality art instruction in a unique format, the books in this series are designed with the aspiring artist in mind. Based on the best-selling books from Walter Foster's How to Draw and Paint series, these six titles showcase an exciting array of subjects to re-create in pencil—from stunning floral scenes to lifelike portraits. Each book provides a helpful introduction to pencil drawing, complete with information on tools, materials, and basic techniques. These how-to-draw books also feature concealed wire-o binding, so artists can lay them flat while they draw. And each title in this series includes twenty pages of drawing paper bound into the back of the book—perfect for artists on the go!

THT266

THT267

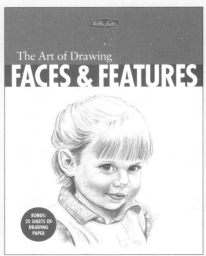

THT290

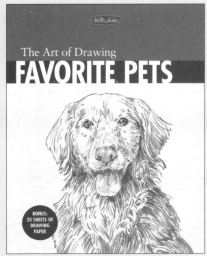

THT286

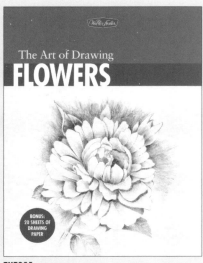

THT255

THT11

MORE TITLES COMING SOON!

For more than 80 years, products bearing the Walter Foster name have introduced millions of budding artists to the joys of creative self-expression in painting and drawing. Continuing that tradition of quality and authority, each of Walter Foster's The Art of Drawing books is a 32-page art lesson that will expand your knowledge of different drawing techniques. Ask for these books at your local arts and crafts store, or visit our website at www.walterfoster.com. You'll want to collect them all!